Alberta Hutchinson's
Peaceful Mandalas

Racehorse Publishing books may be purchased in bulk at special discounts for sales promotion, corporate gifts, fund-raising, or educational purposes. Special editions can also be created to specifications. For details, contact the Special Sales Department, Skyhorse Publishing, 307 West 36th Street, 11th Floor, New York, NY 10018 or info@skyhorsepublishing.com.

Racehorse Publishing™ is a pending trademark of Skyhorse Publishing, Inc.®, a Delaware corporation.

Visit our website at www.skyhorsepublishing.com.

10 9 8 7 6 5 4 3 2 1

Cover design by Brian Peterson
Cover artwork by Alberta Hutchinson

Print ISBN: 978-1-944686-00-0

Printed in the United States of America

Alberta Hutchinson's
Peaceful Mandalas

New York Times **Bestselling Artists' Adult Coloring Books**

Racehorse Publishing

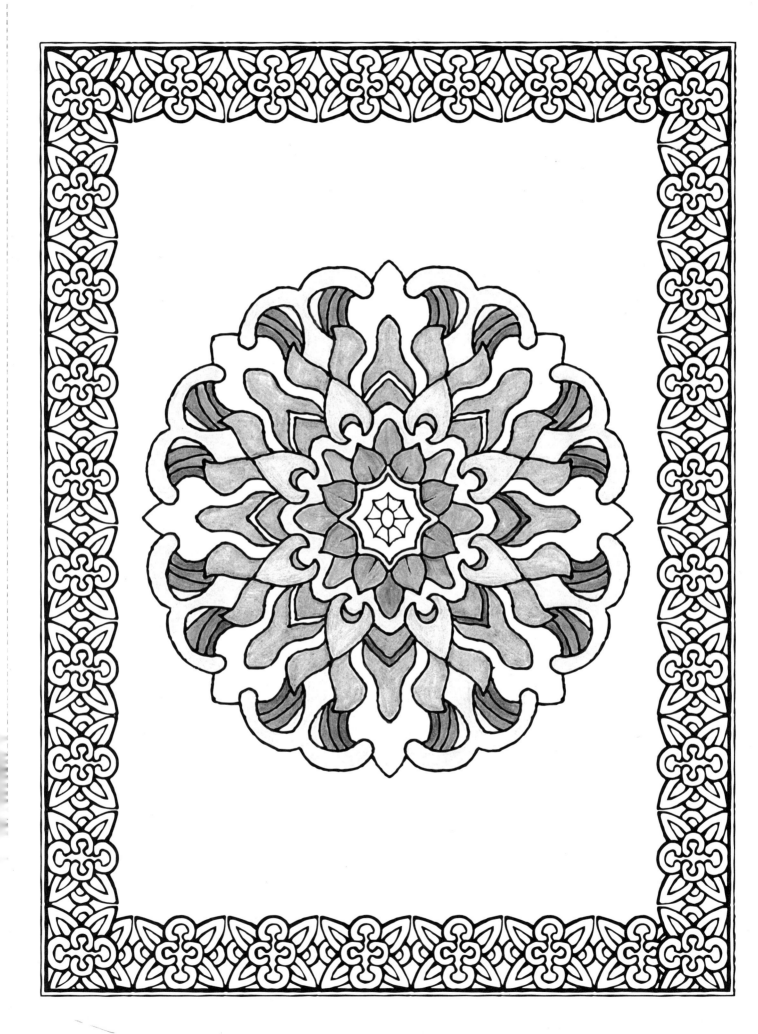

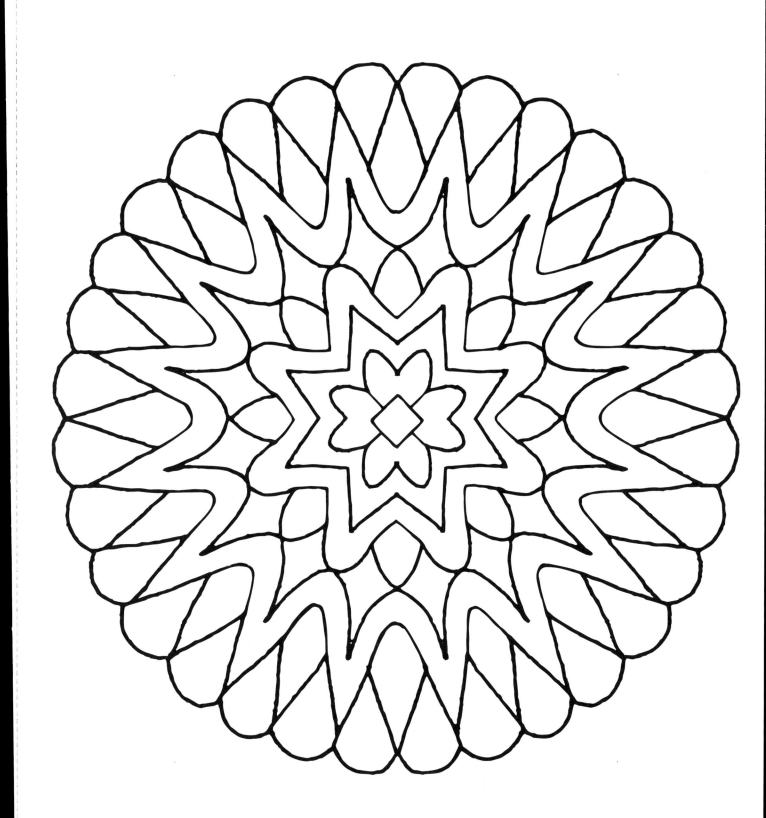

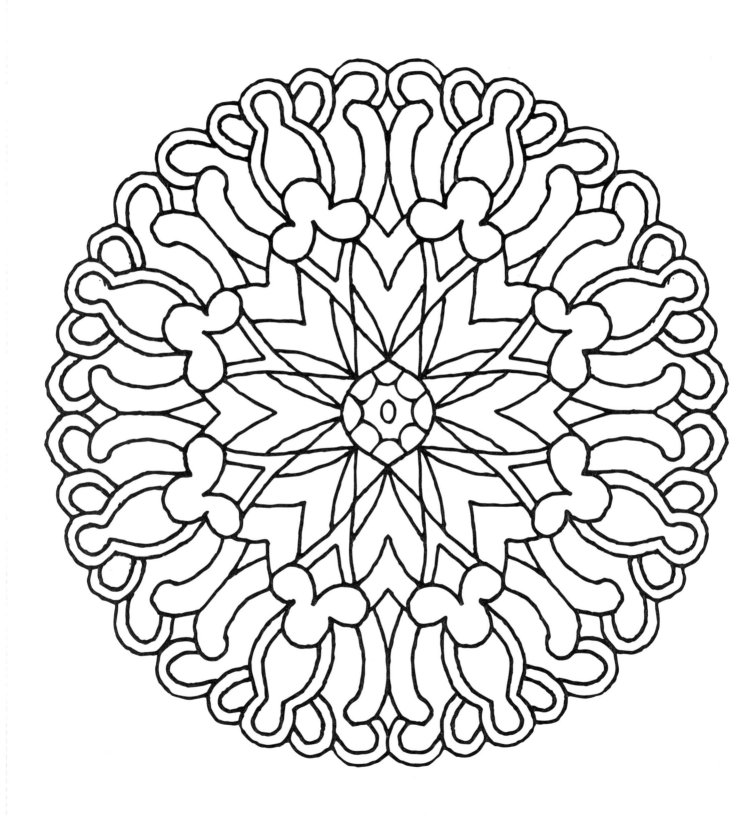

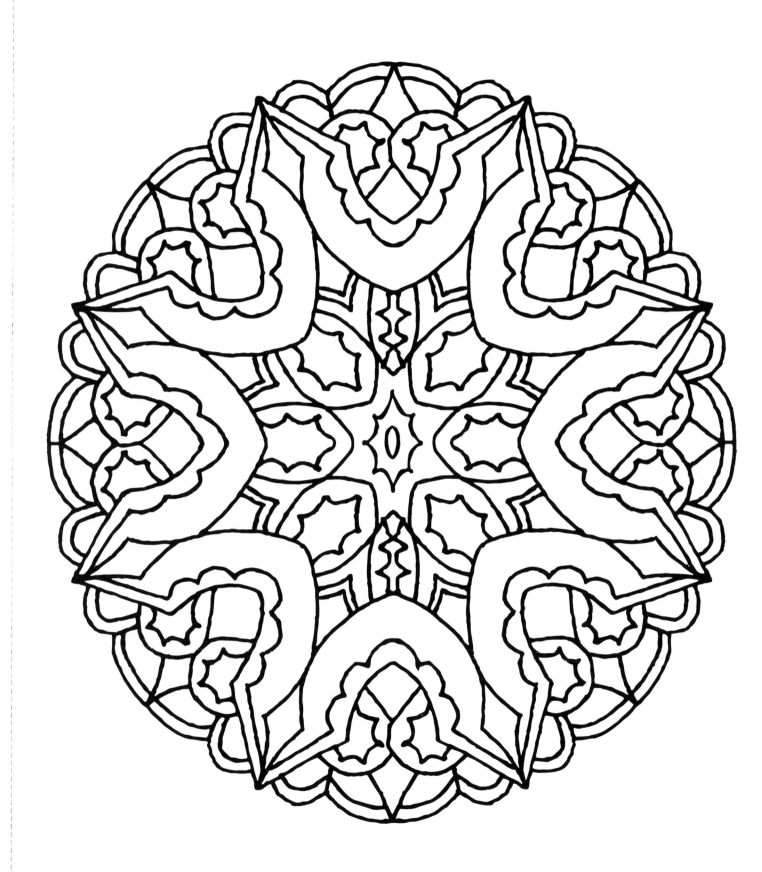

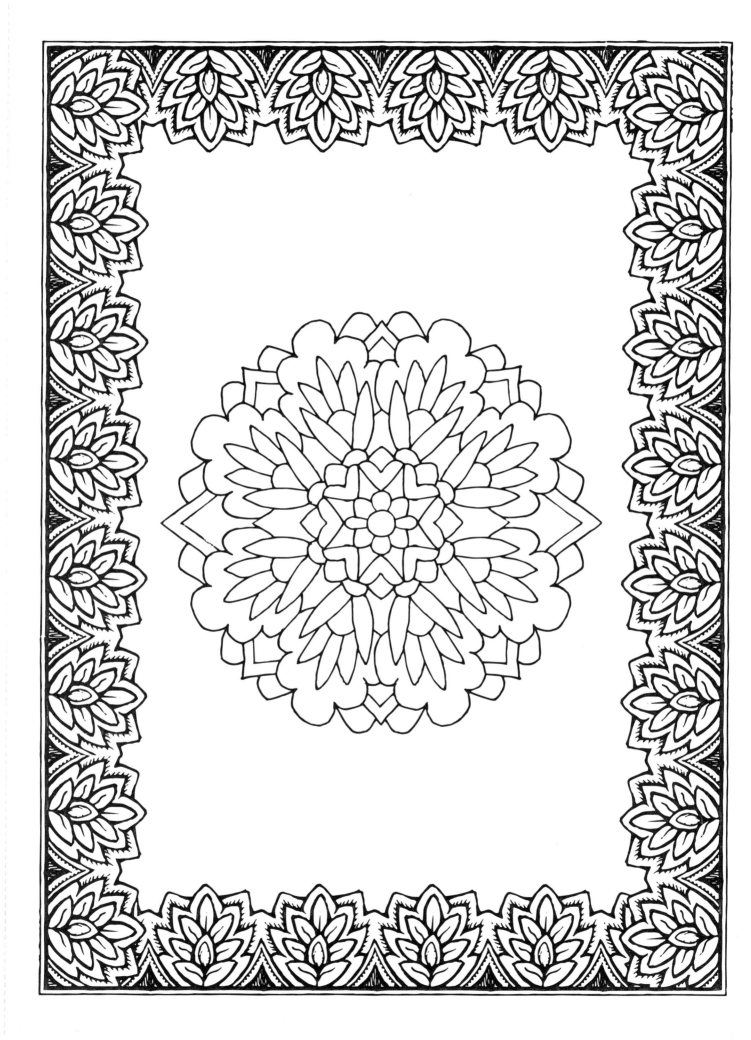

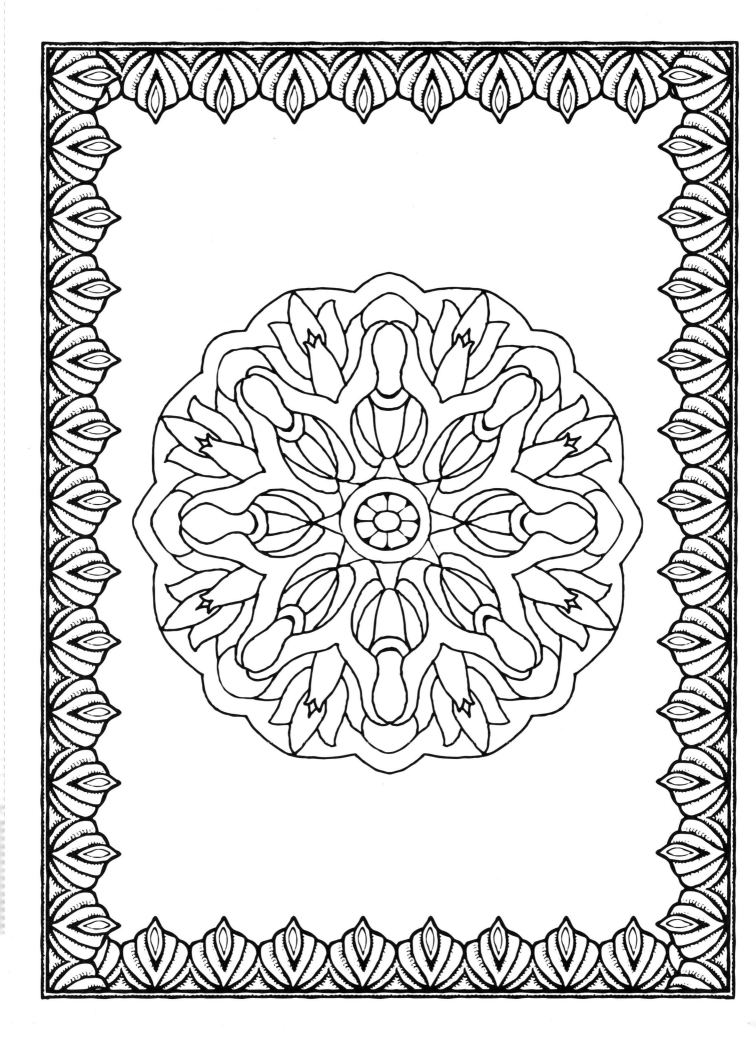

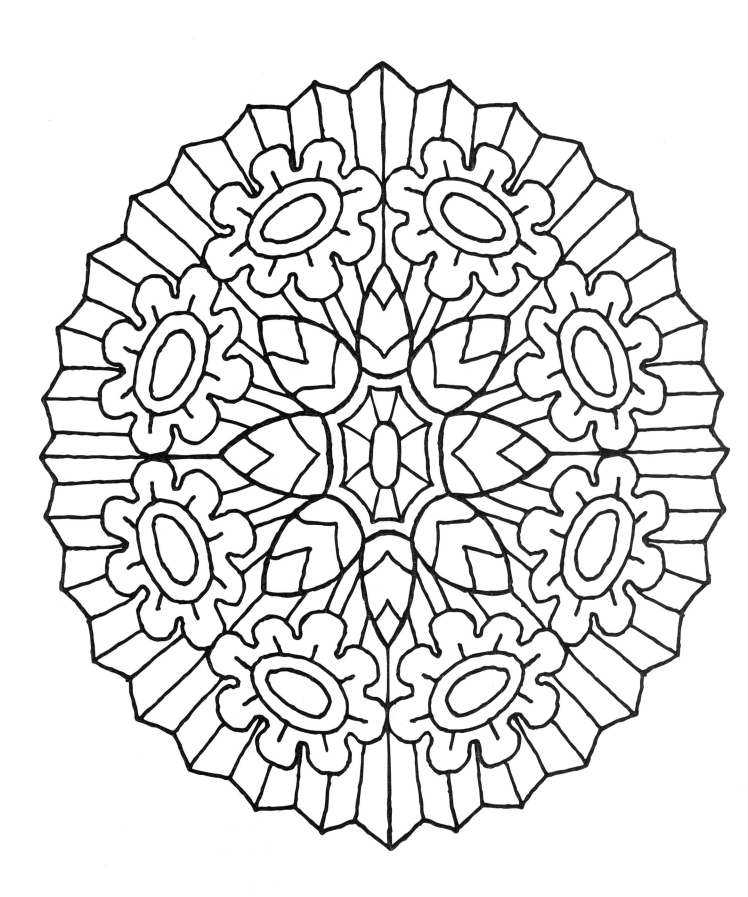

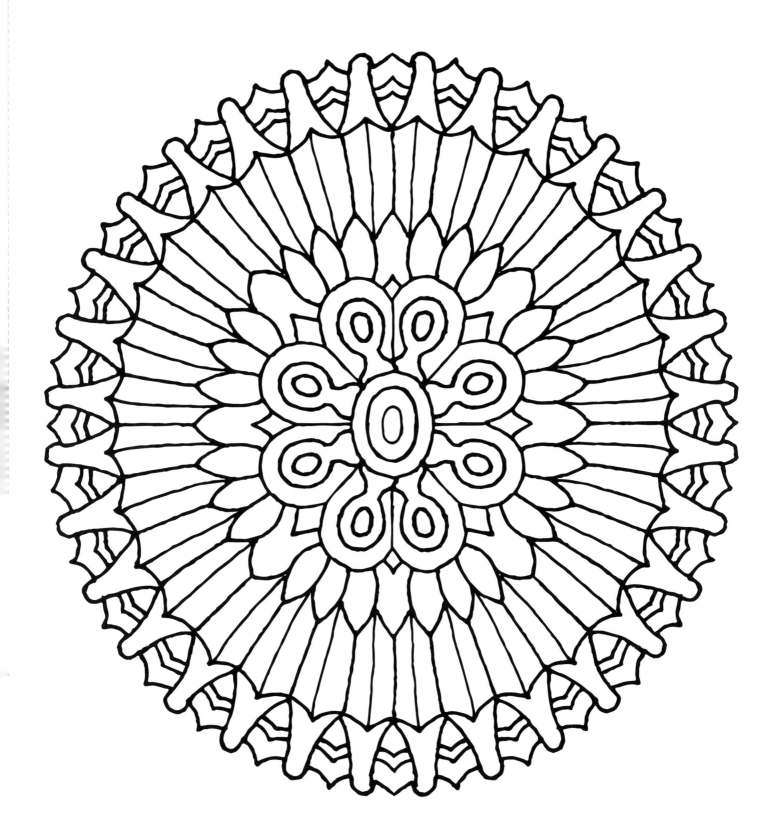

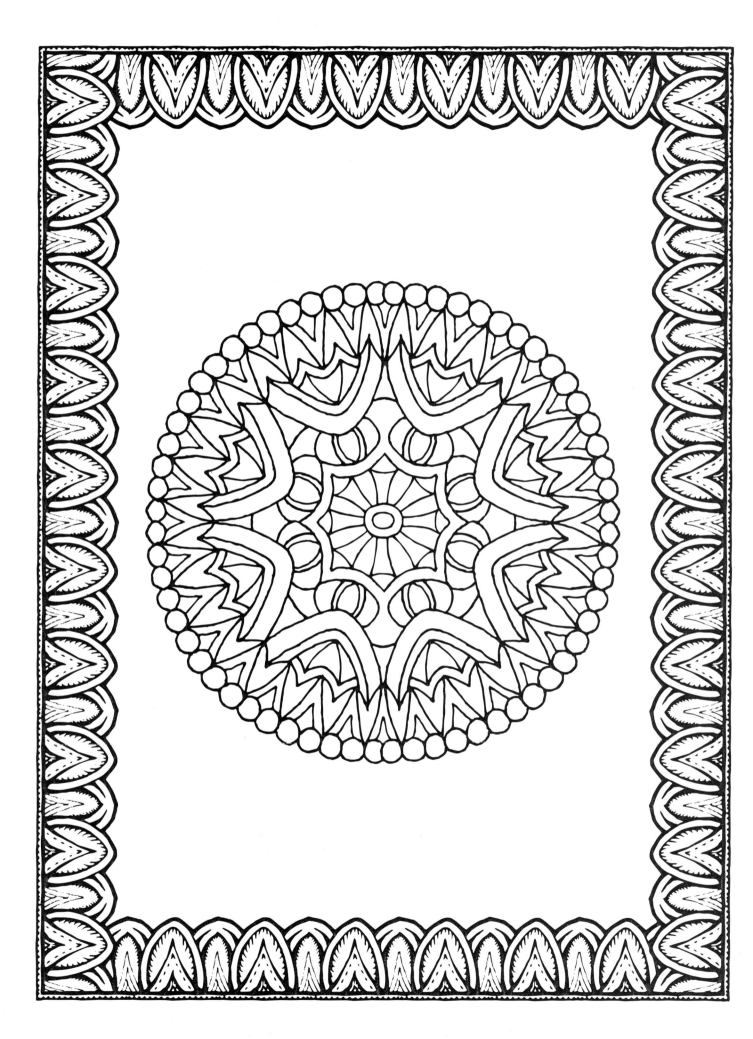

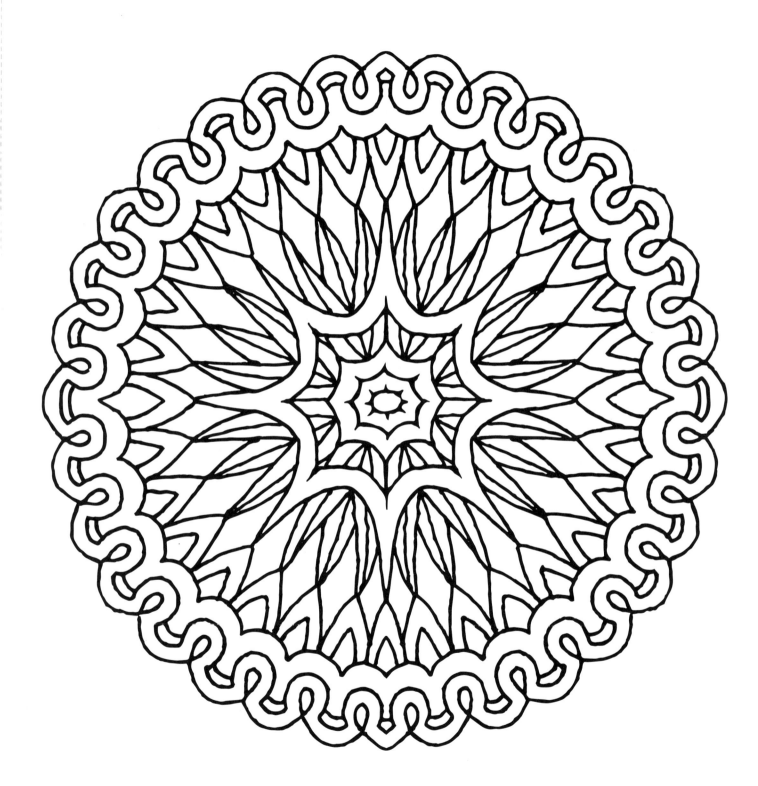

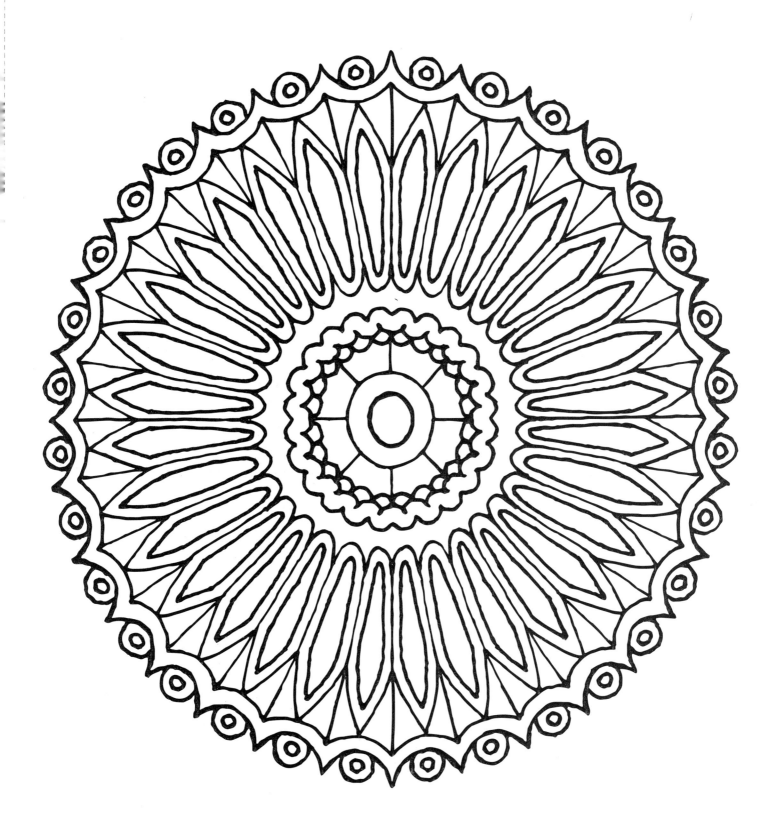

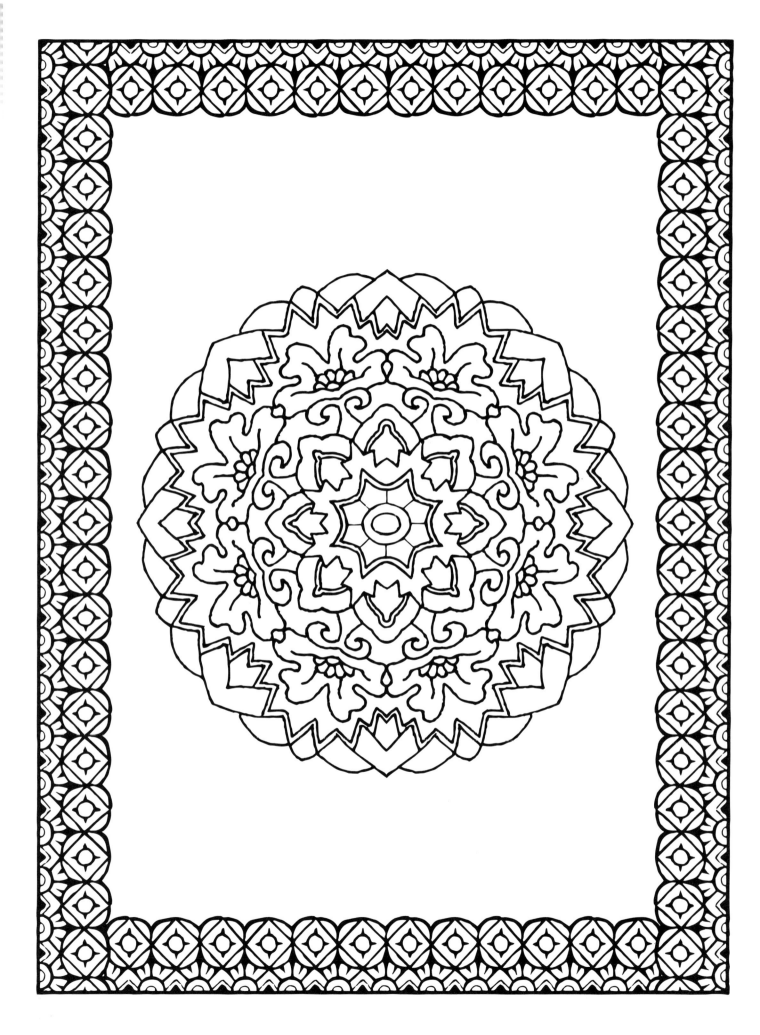

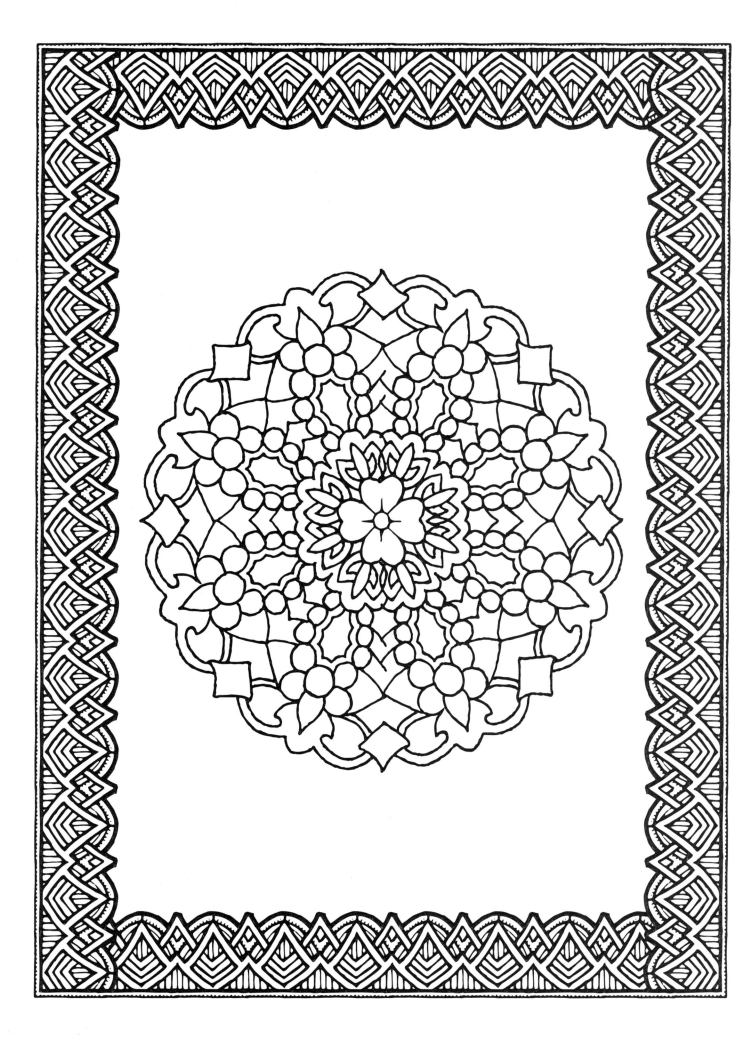

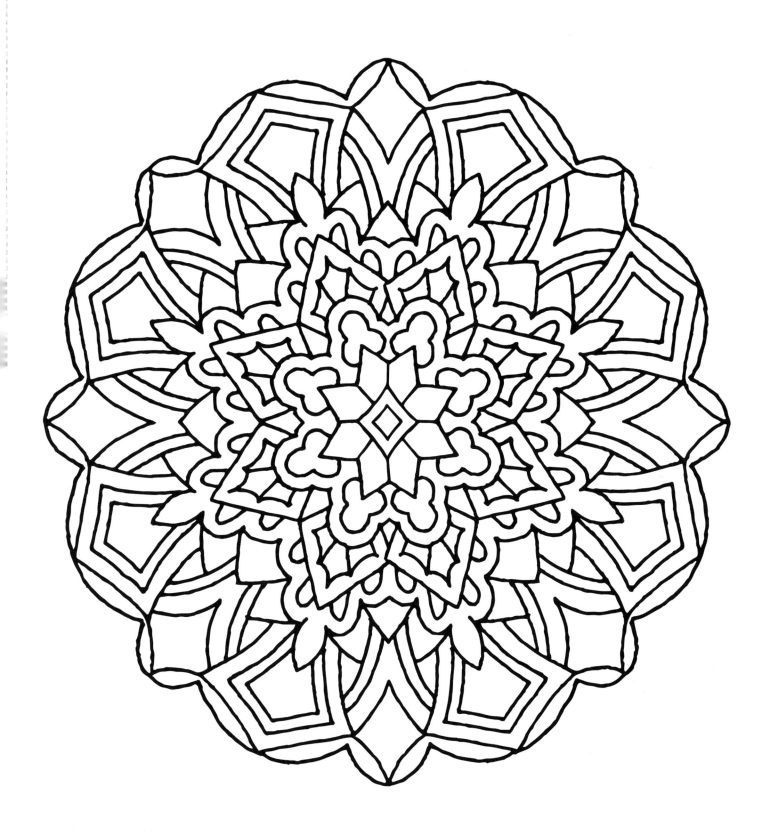

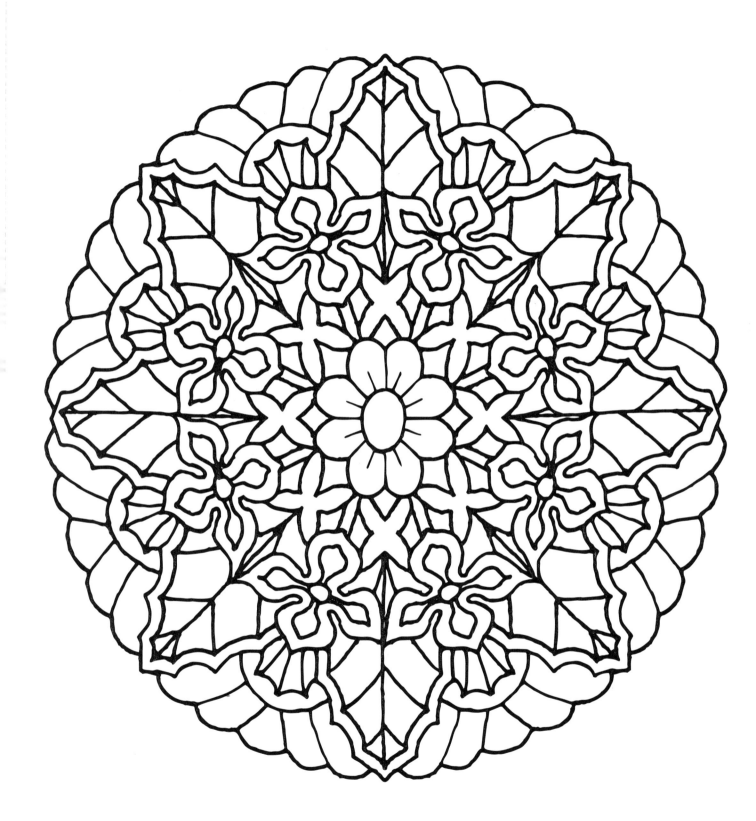

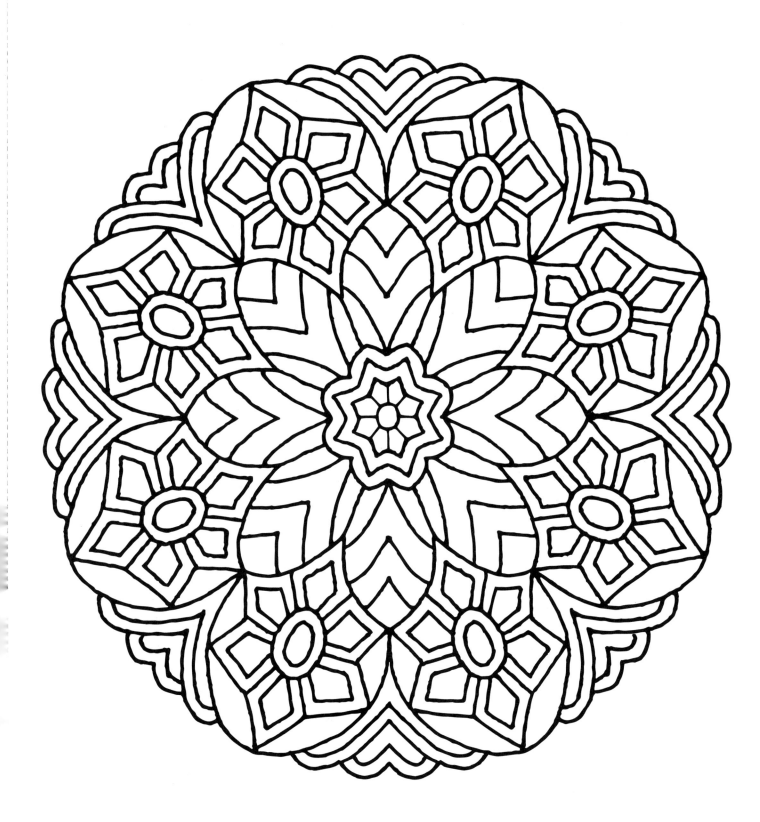

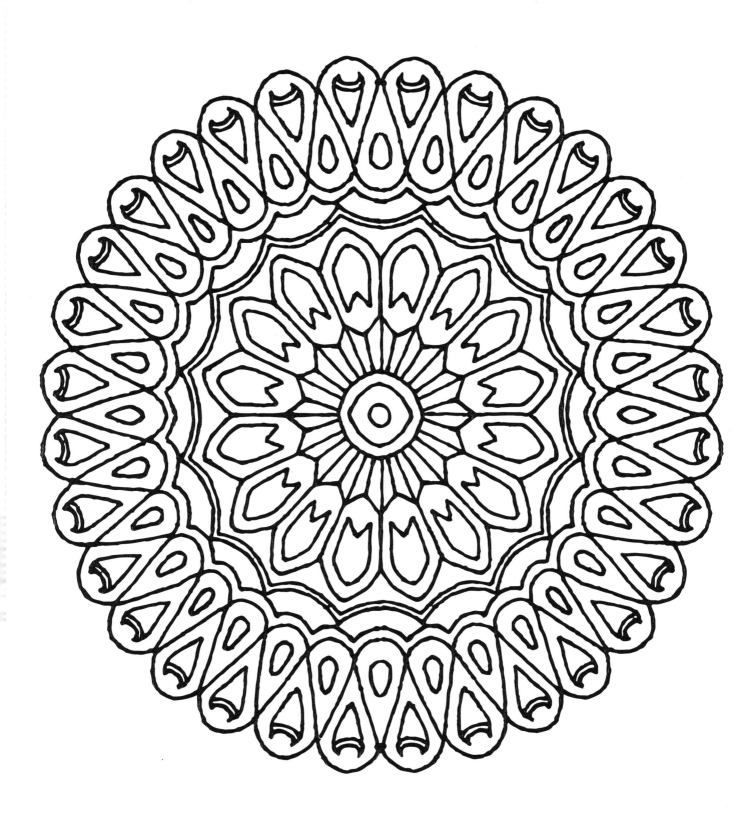

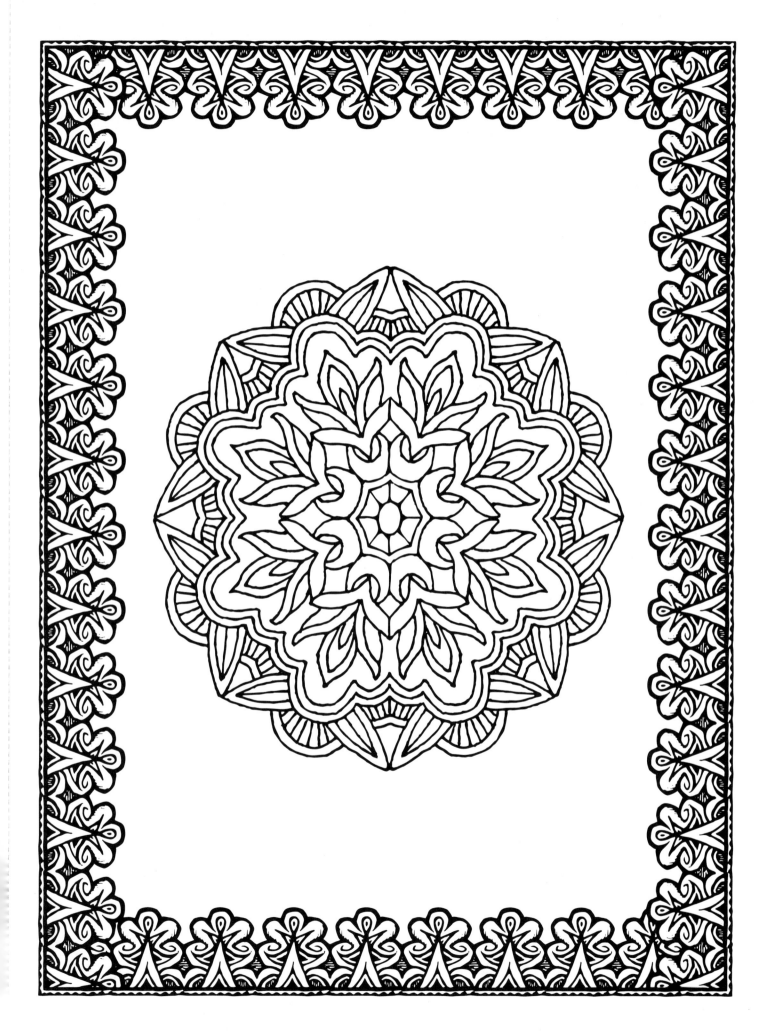

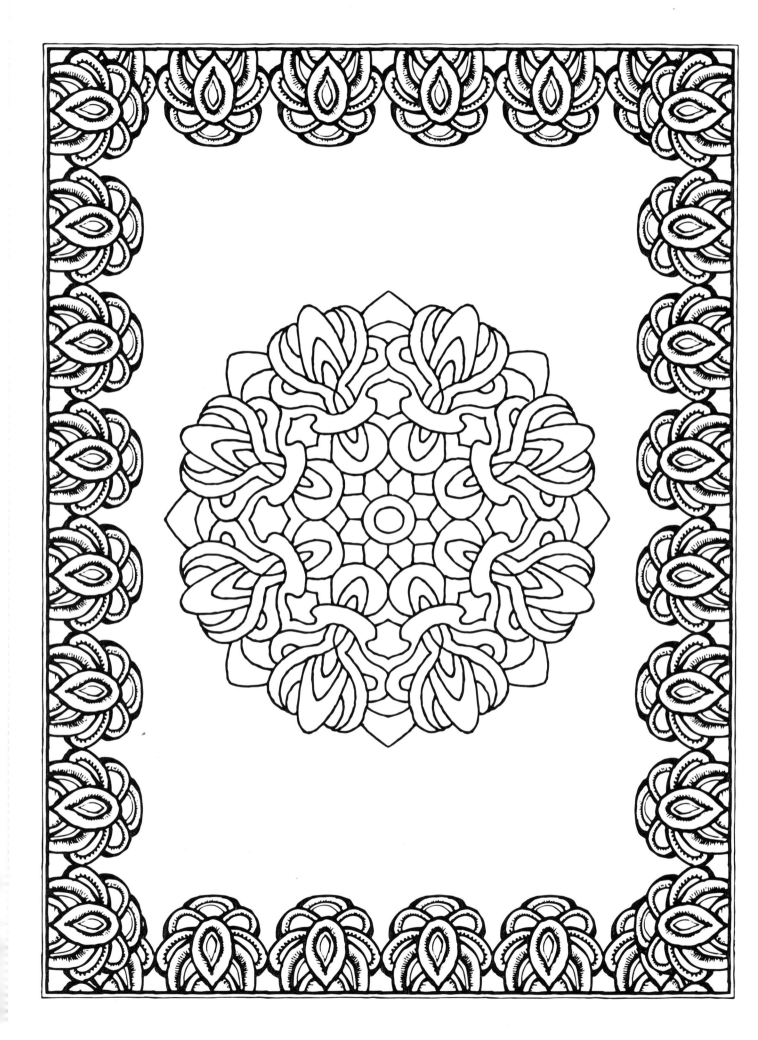

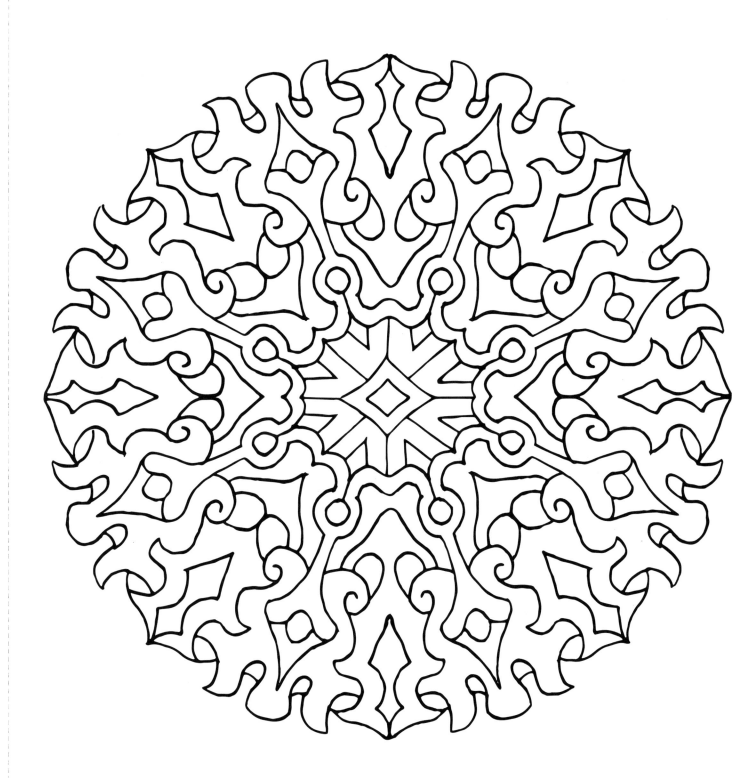

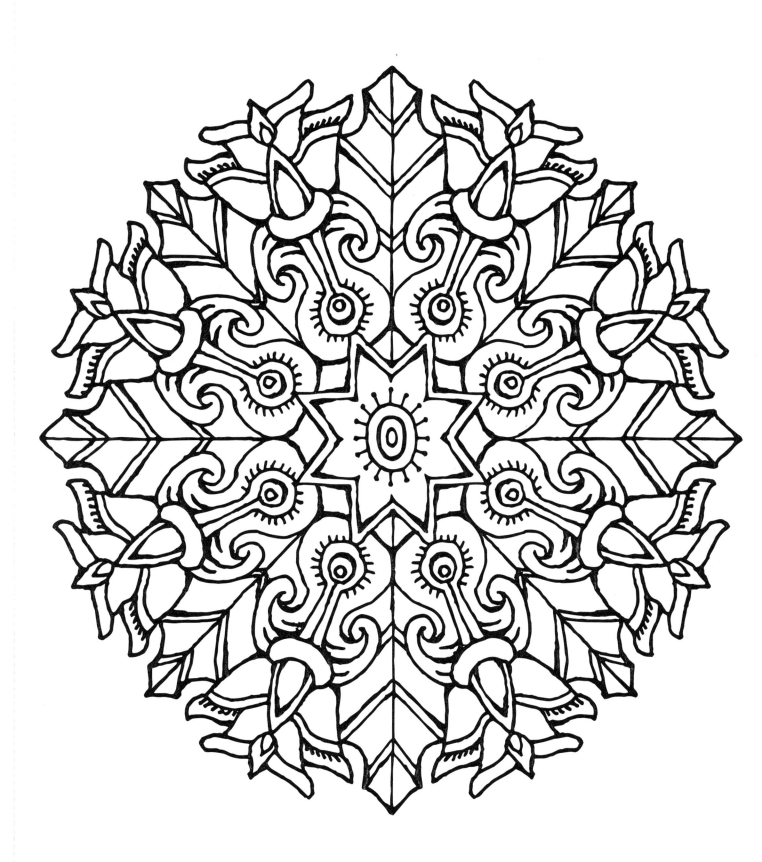

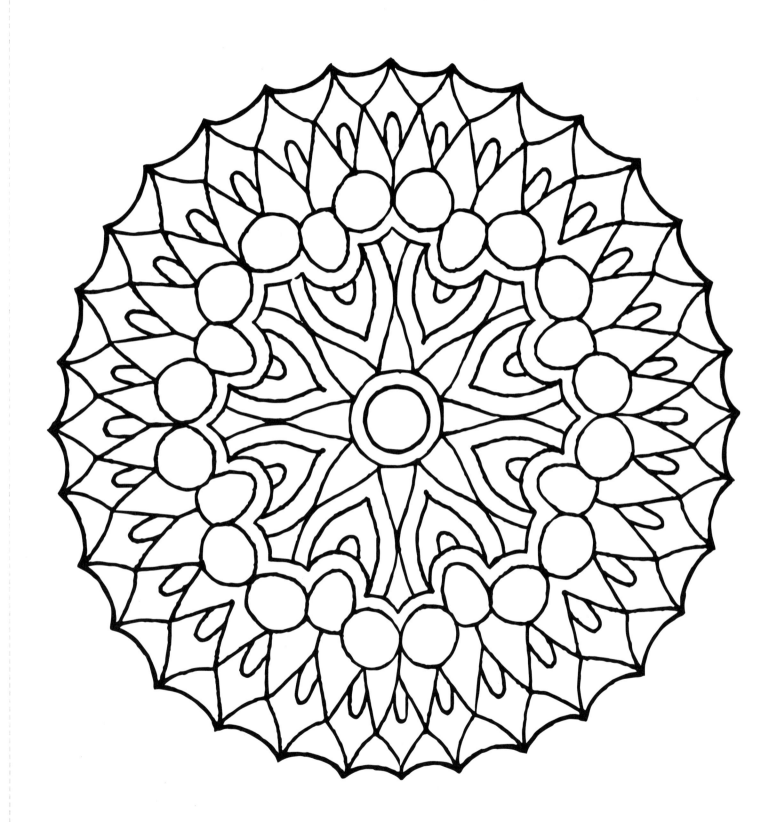

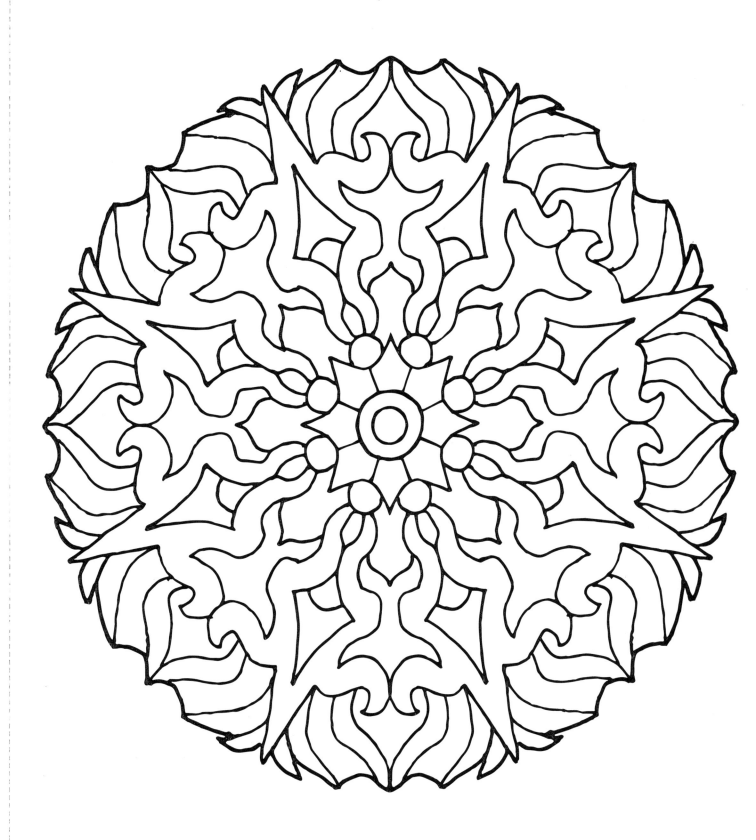

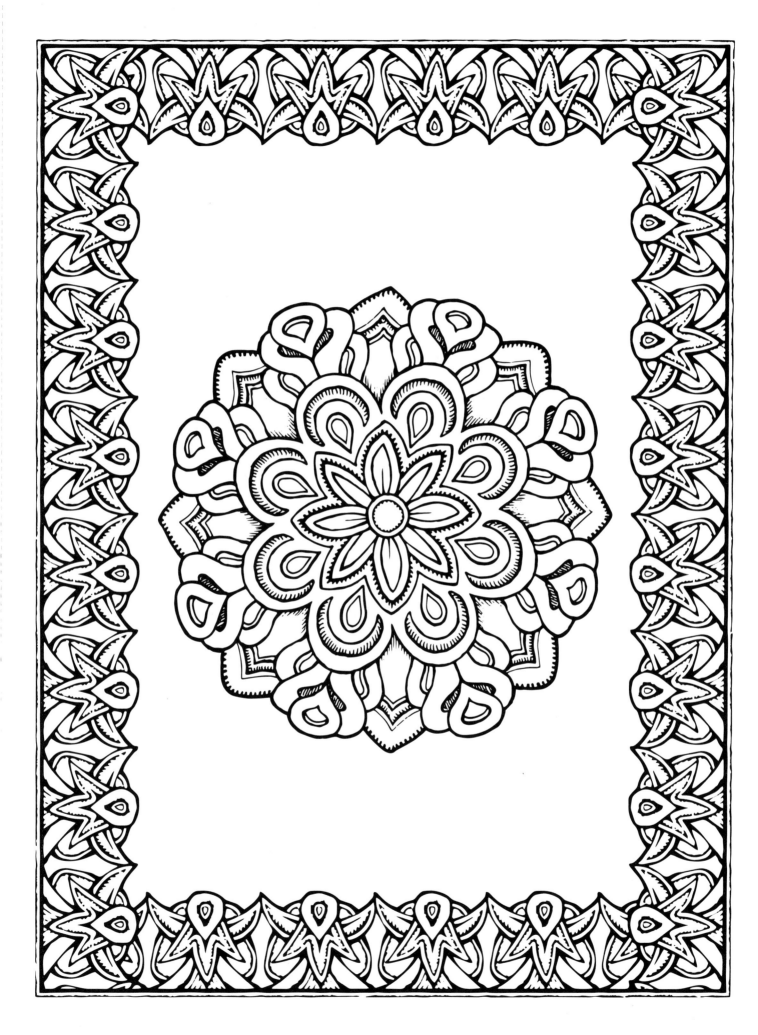

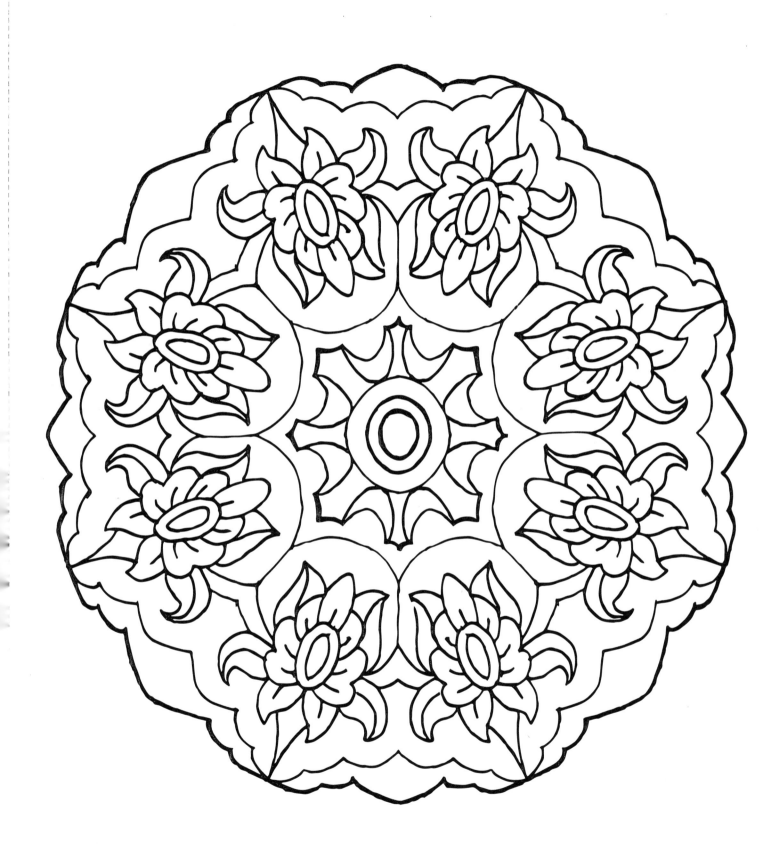

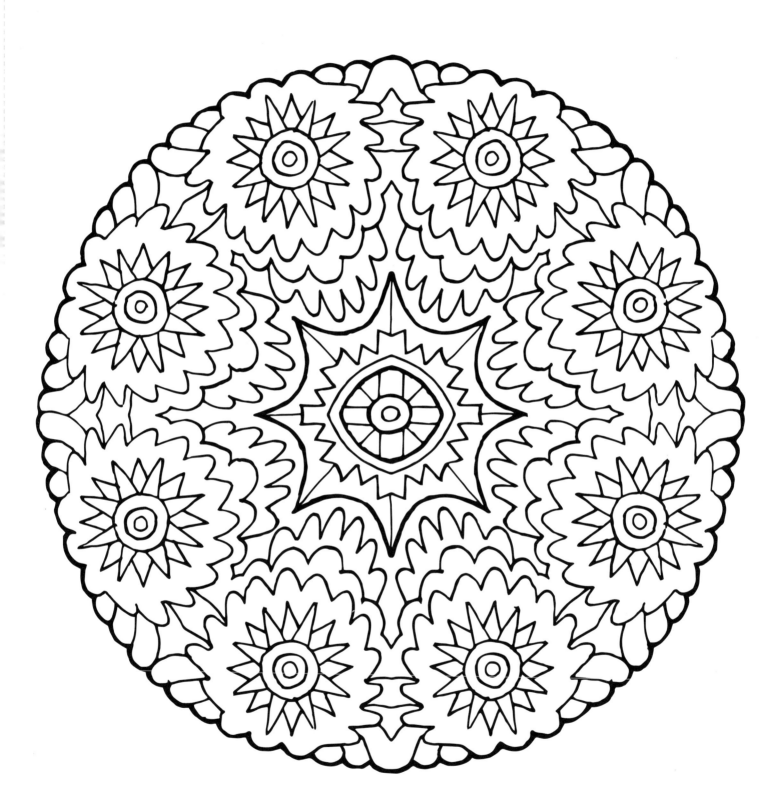

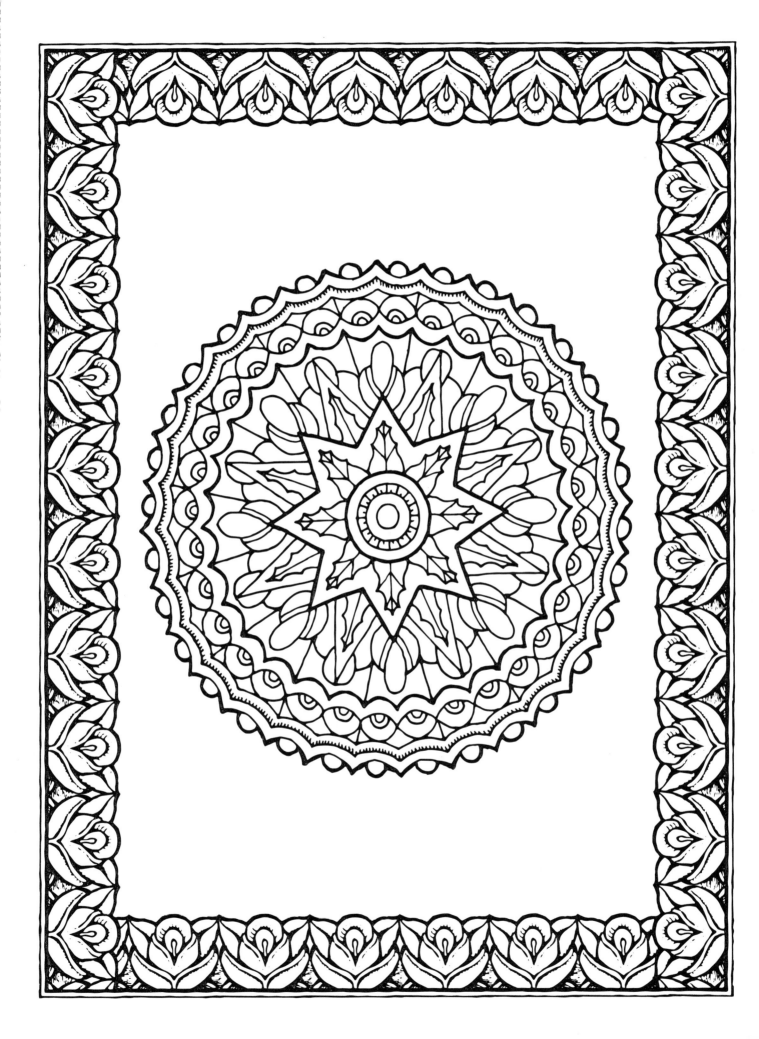

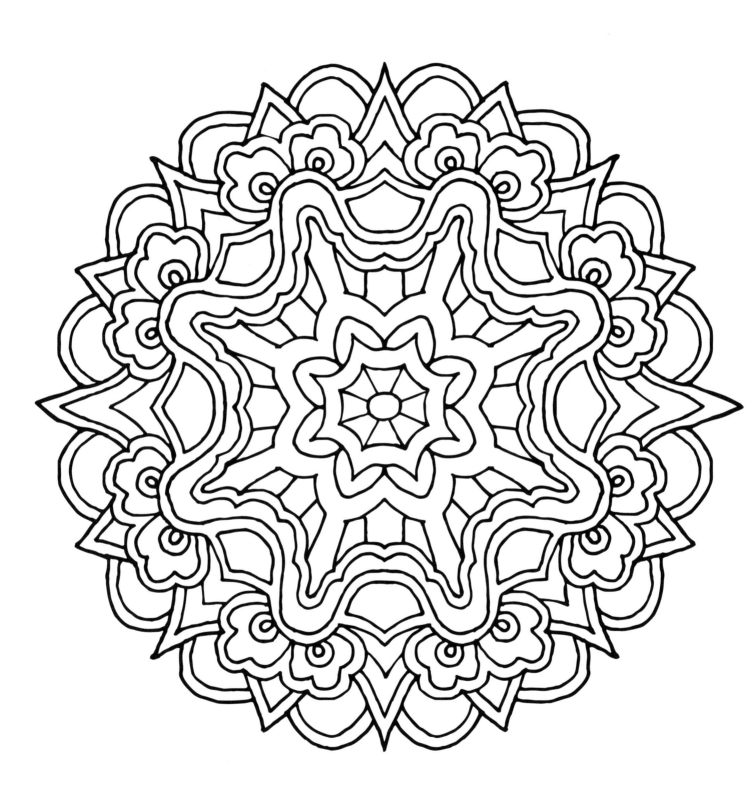

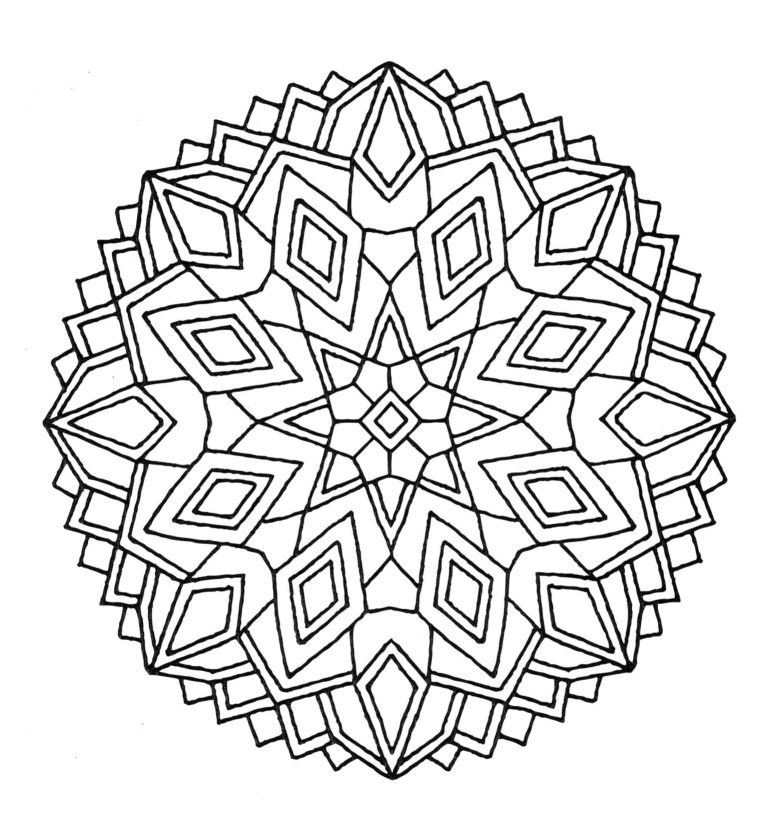

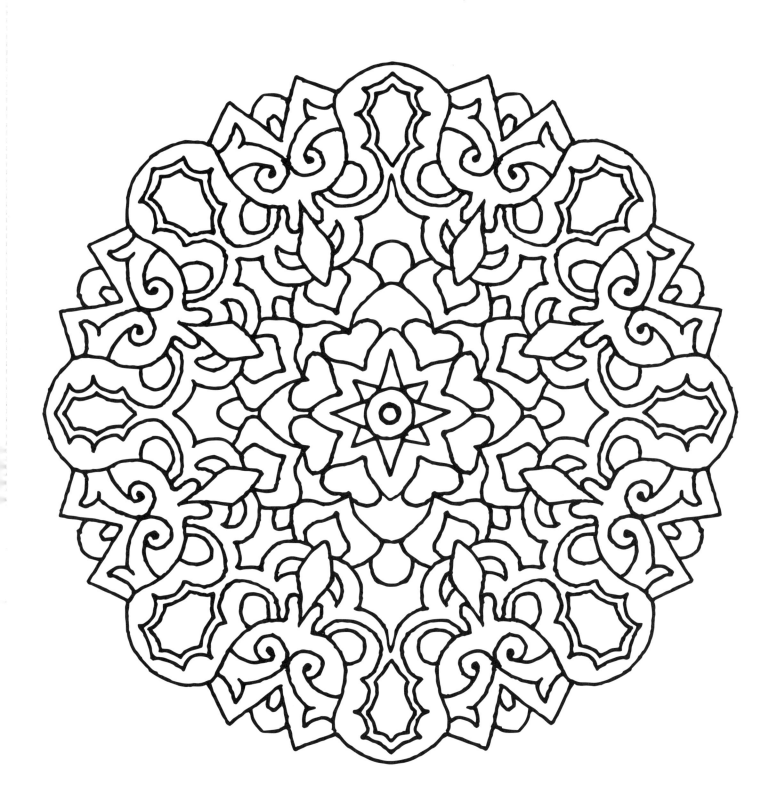

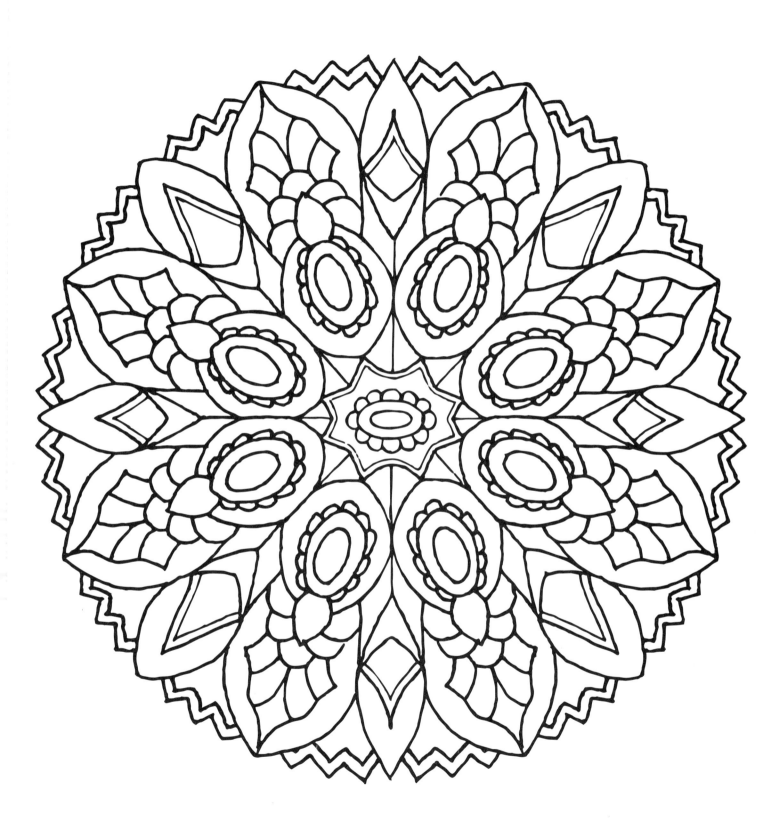

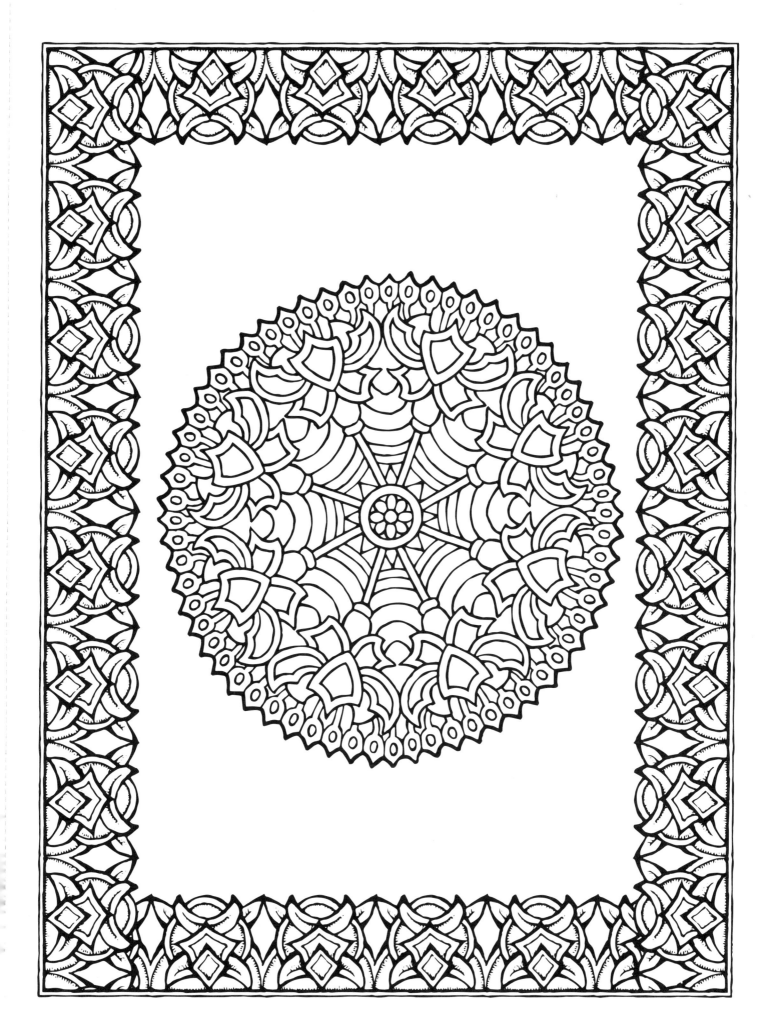

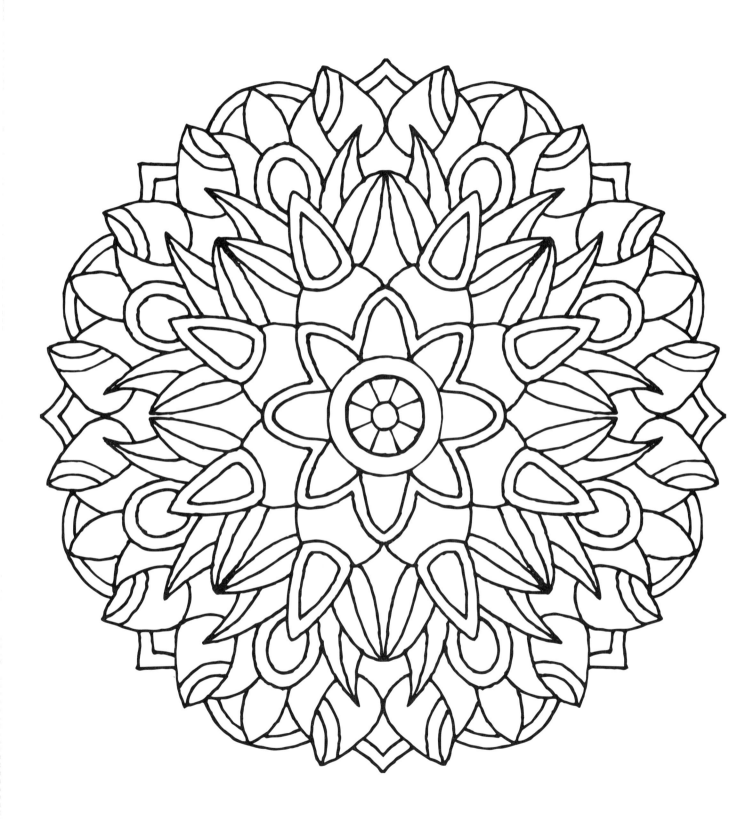

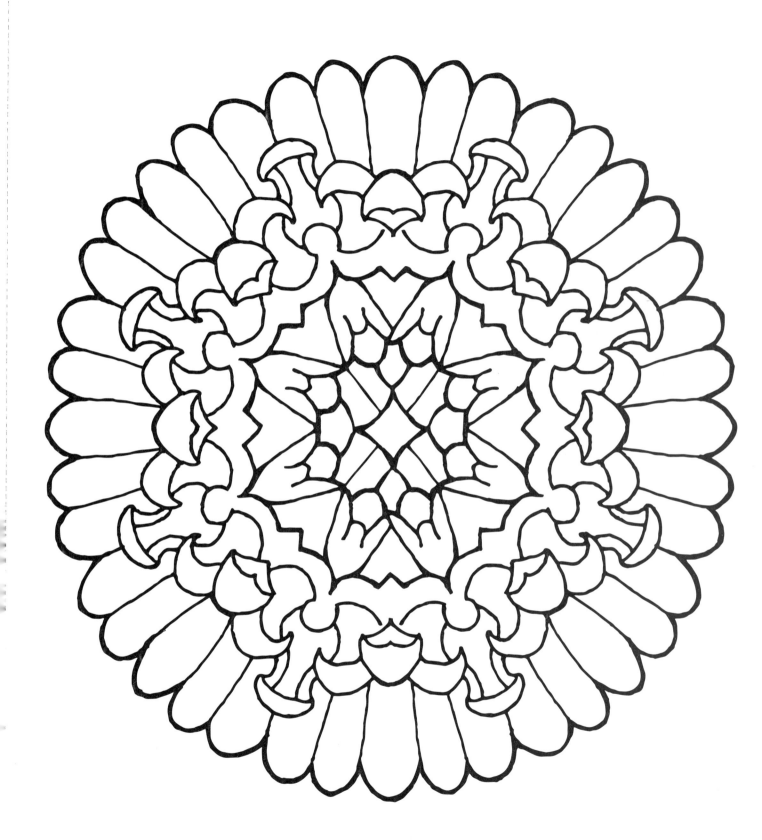

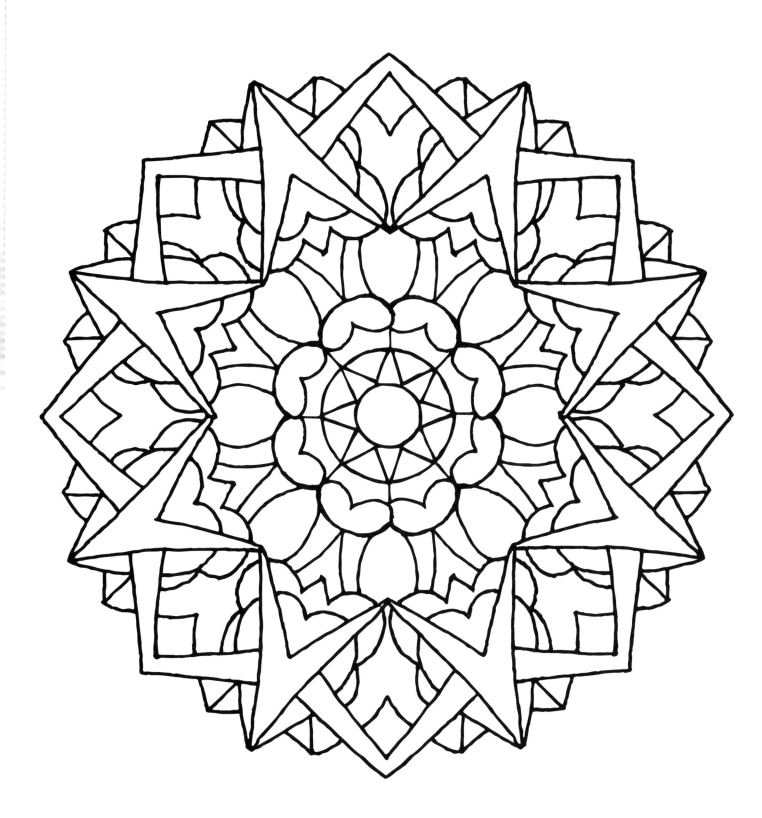

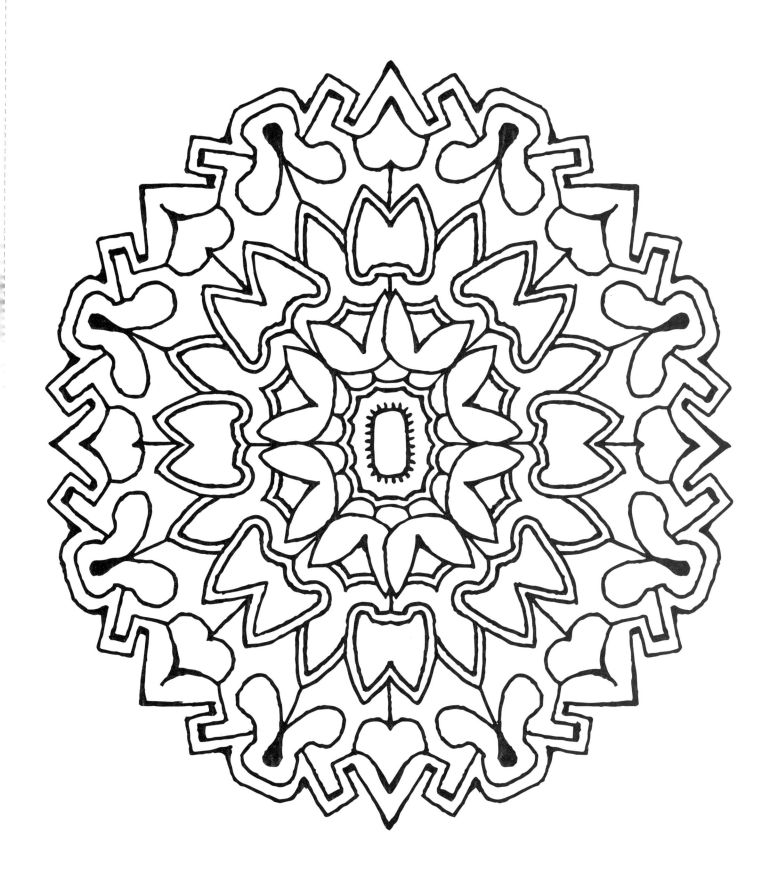

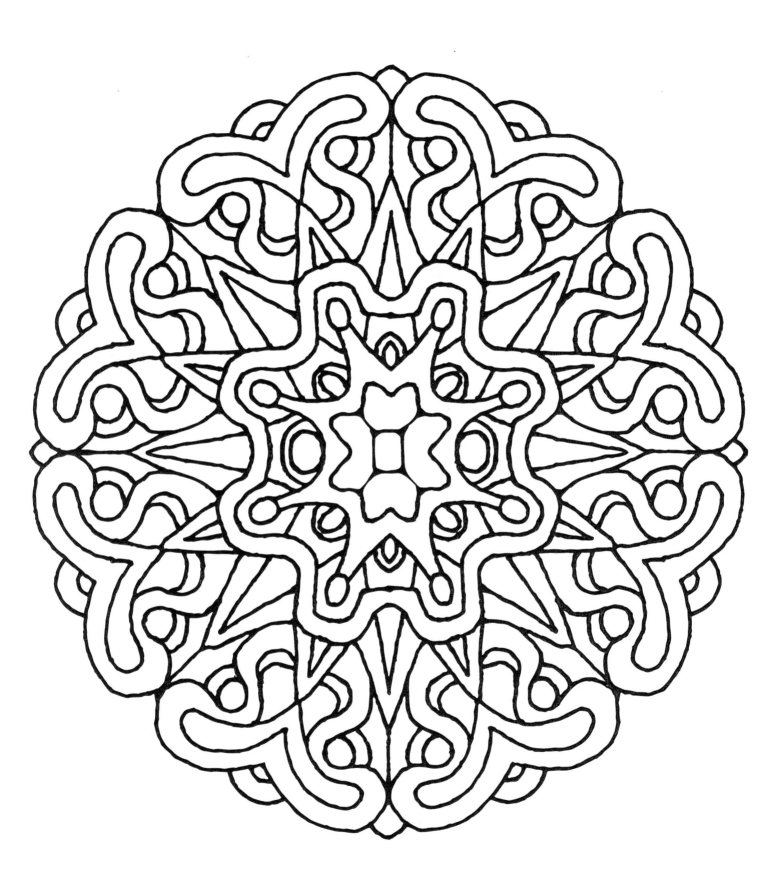

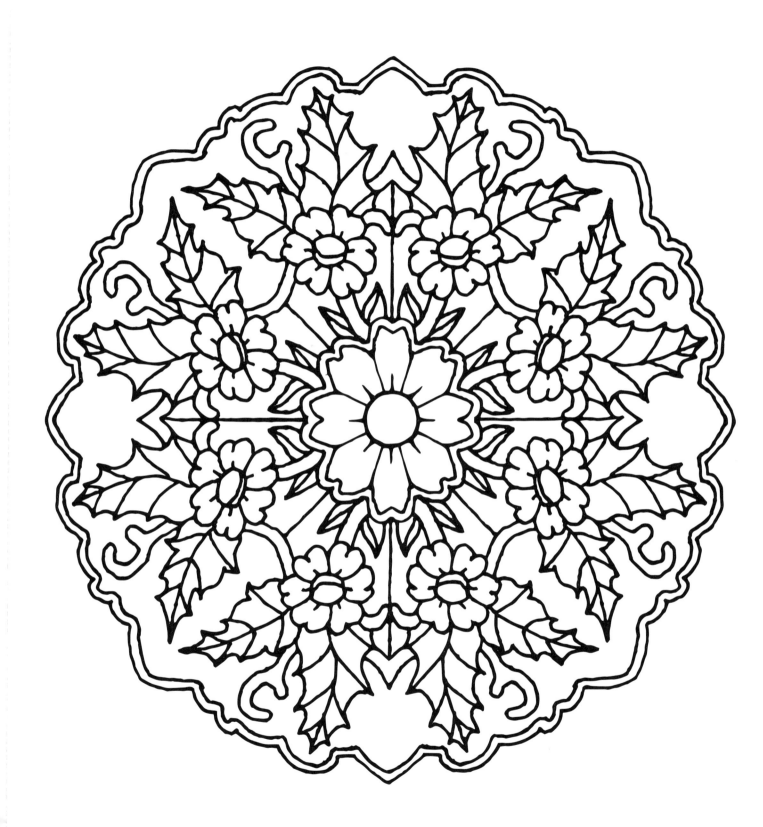

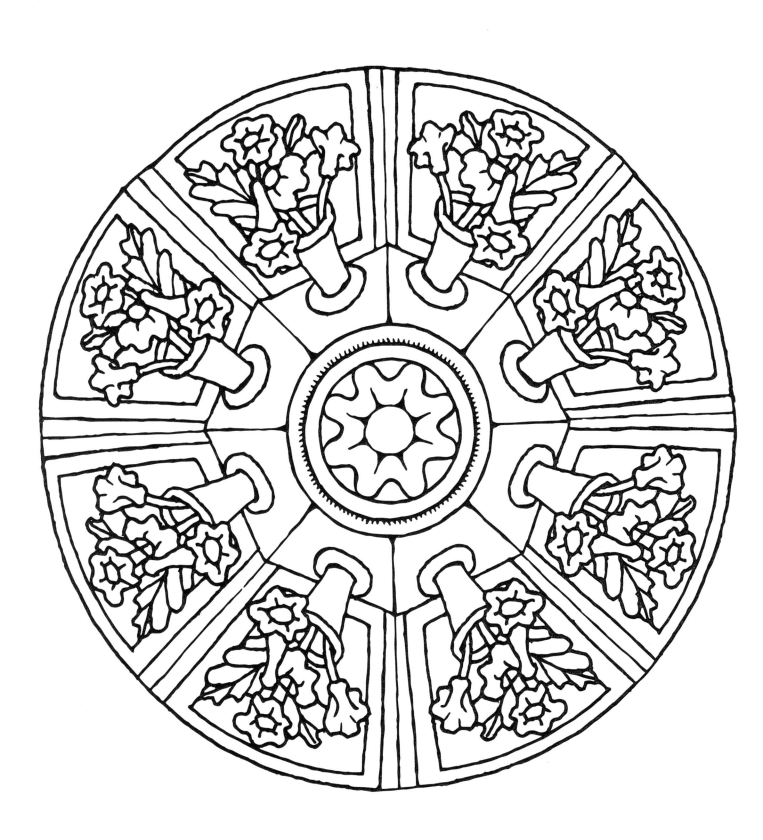

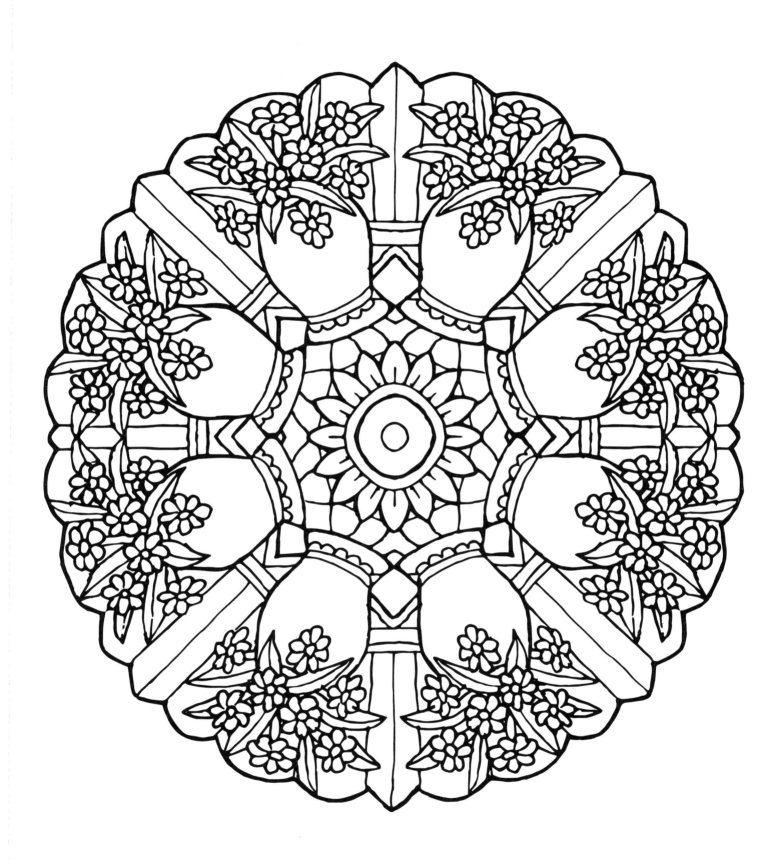

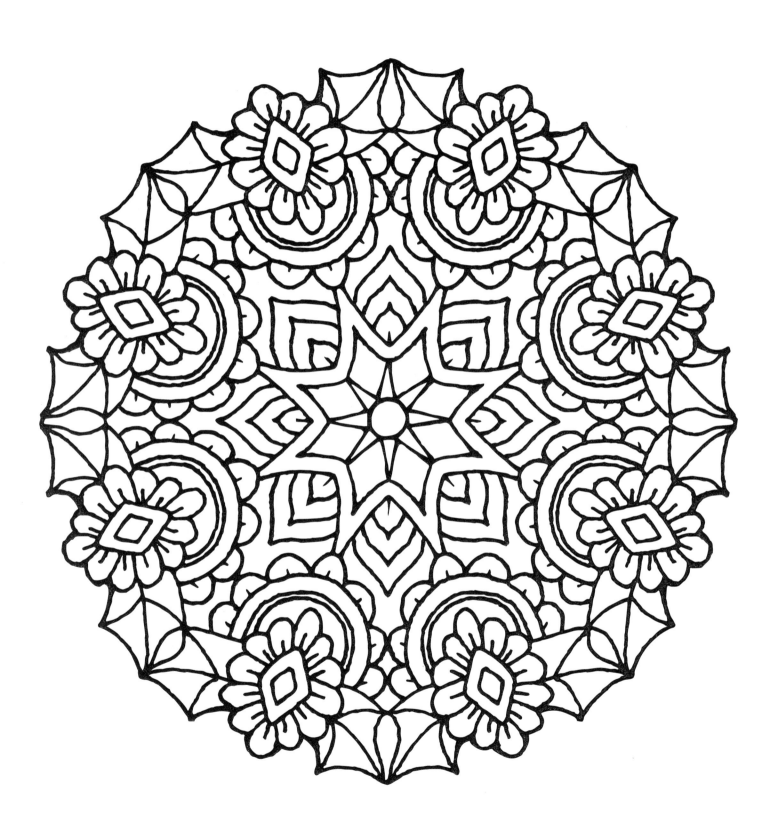

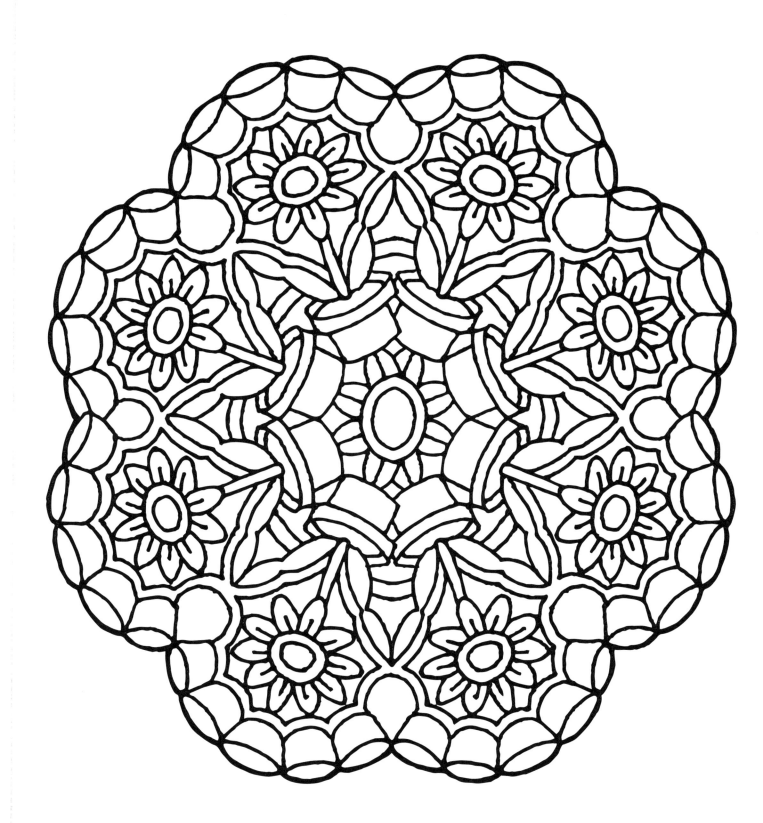

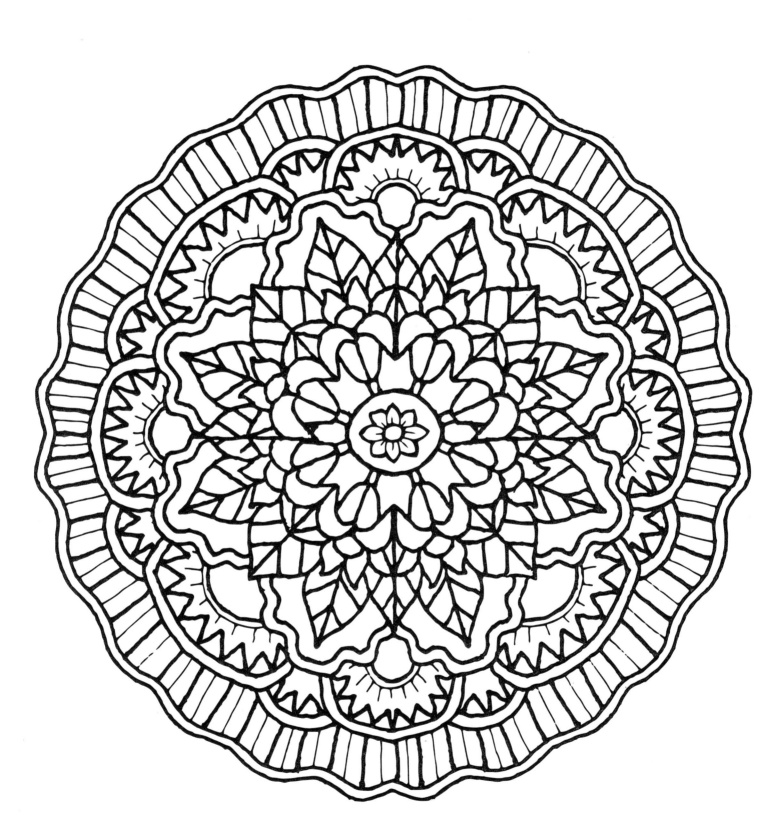

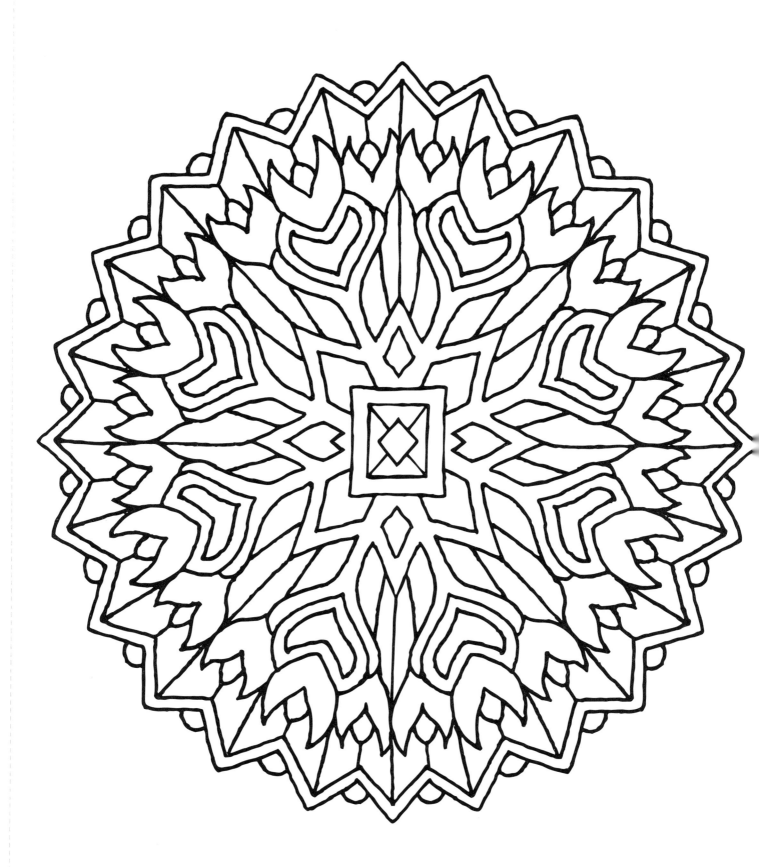

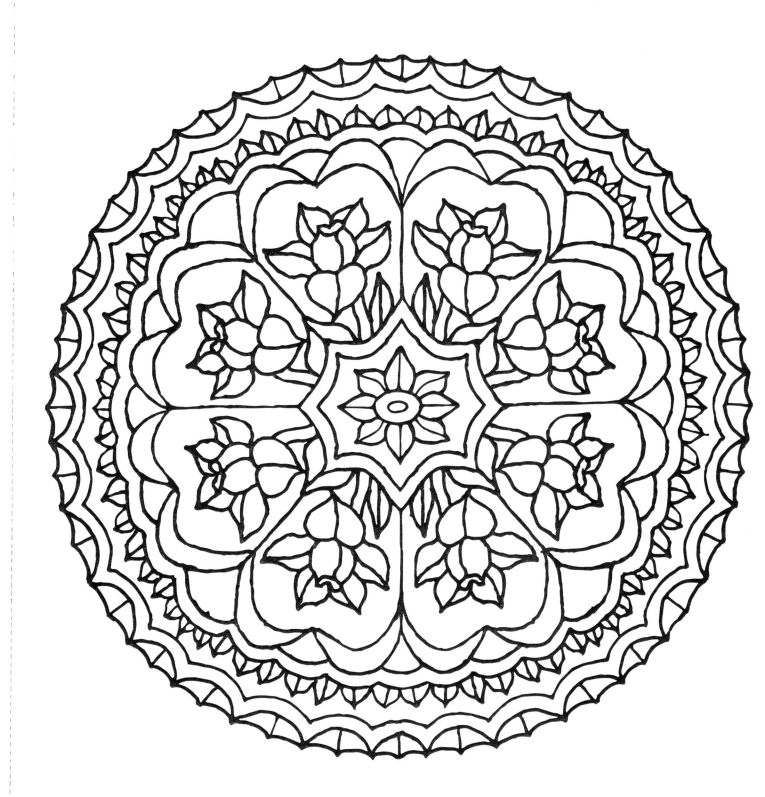

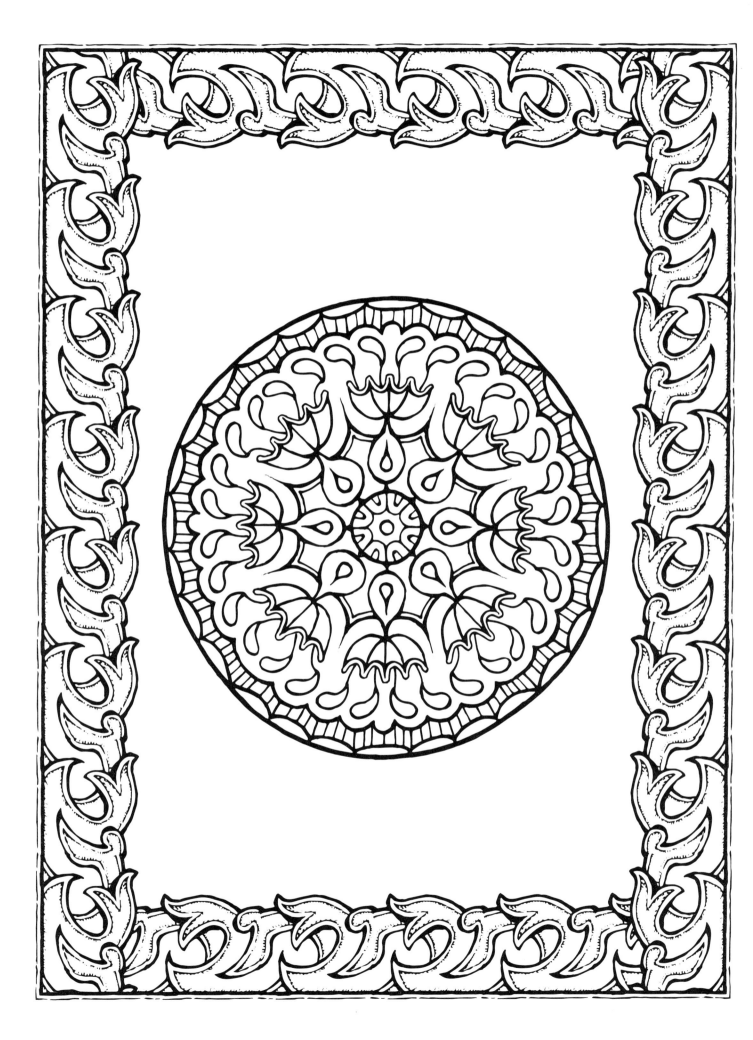

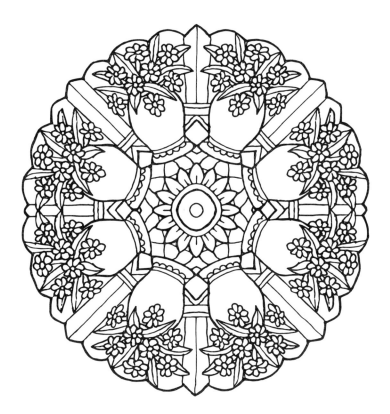

Mandalas are among some of the oldest designs created by the human race. Translating loosely from Sanskrit to "circle" or "center," "Mandalas" are typically round, and consist primarily of highly detailed, symmetrical patterns that extend outward from a central focal point. This cyclical format is intended to symbolize the totality of the cosmos and the wholeness of life that radiates from one's center. Various traditions have utilized them to assist with focus and aid in mediation—most commonly, within Hindu and Buddhist practices. However, their balance, geometric composition, and colorful patterns can be calming to study regardless of your spiritual orientation.

Throughout history, Mandalas have become recognized as symbols of inner peace and tranquility. Consequently, this has made them ideal candidates to incorporate into adult coloring books. Coloring in their soothing, swirling patterns while focusing on their repetitive symmetry is found to be highly meditative and expressive, and helps to alleviate stress. With *Alberta Hutchinson's Peaceful Mandalas*, you'll find harmony in applying your own creative color choices to these magical illustrations.

ↄ

Alberta Hutchinson is a master designer and colorist, as well as a notable artist of other media. In the course of her career she has created thousands of works, including coloring books, illustrated and design books, ornaments, quilts, and fabrics. She is particularly well-known for her elaborately designed borders, which frame many of her illustrations. Additionally, she has published more than thirty books, including a novel and poetry featuring her artwork. Most notably among Hutchinson's collection are her bestselling mandala and design coloring books, which delight colorists of all ages and levels of skill.

Also Available from Skyhorse Publishing

Creative Stress Relieving Adult Coloring Book Series
Art Nouveau: Coloring for Artists
Art Nouveau: Coloring for Everyone
Butterfly Gardens: Coloring for Everyone
Curious Cats and Kittens: Coloring for Artists
Curious Cats and Kittens: Coloring for Everyone
Exotic Chickens: Coloring for Everyone
Mandalas: Coloring for Artists
Mandalas: Coloring for Everyone
Mehndi: Coloring for Artists
Mehndi: Coloring for Everyone
Nature's Wonders: Coloring for Everyone
Nirvana: Coloring for Artists
Nirvana: Coloring for Everyone
Paisleys: Coloring for Artists
Paisleys: Coloring for Everyone
Tapestries, Fabrics, and Quilts: Coloring for Artists
Tapestries, Fabrics, and Quilts: Coloring for Everyone
Whimsical Designs: Coloring for Artists
Whimsical Designs: Coloring for Everyone
Whimsical Woodland Creatures: Coloring for Everyone
Zen Patterns and Designs: Coloring for Artists
Zen Patterns and Designs: Coloring for Everyone

New York Times Bestselling Artists' Adult Coloring Book Series
Marty Noble's Sugar Skulls: New York Times *Bestselling Artists' Adult Coloring Books*
Marty Noble's Peaceful World: New York Times *Bestselling Artists' Adult Coloring Books*
Majorie Sarnat's Fanciful Fashions: New York Times *Bestselling Artists' Adult Coloring Books*
Marjorie Sarnat's Pampered Pets: New York Times *Bestselling Artists' Adult Coloring Books*

The Peaceful Adult Coloring Book Series
Adult Coloring Book: Be Inspired
Adult Coloring Book: De-Stress
Adult Coloring Book: Keep Calm
Adult Coloring Book: Relax

Portable Coloring for Creative Adults
Calming Patterns: Portable Coloring for Creative Adults
Flying Wonders: Portable Coloring for Creative Adults
Natural Wonders: Portable Coloring for Creative Adults
Sea Life: Portable Coloring for Creative Adults